Penguin Books

Penguin New Art 3    Advisory Editor: Richard Morphet

David Thompson was Art Critic of *The Times* from 1956 to 1963 and besides frequent contributions to *Studio International,* the *New York Times,* the *Listener* and *Queen* magazine, has written for the *Observer,* the *Sunday Times,* the *Spectator, Art News* and *Das Kunstwerk.* Catalogue introductions include that for the first 'New Generation' exhibition at the Whitechapel Gallery in 1964, and as a member of the Fine Arts Advisory Committee of the British Council, he has written catalogues for the Biennales at Venice, São Paulo and Paris. He has directed three art films for the Arts Council of Great Britain on Francis Bacon, Turner and The Pre-Raphaelite Revolt.

D1199957

Robyn Denny

by David Thompson

Penguin Books Ltd, Harmondsworth, Middlesex, England
Penguin Books Inc., 7110 Ambassador Road, Baltimore,
Maryland 21207, U.S.A.
Penguin Books Australia Ltd, Ringwood, Victoria, Australia

First published 1971
Copyright © David Thompson, 1971
Designed by Gerald Cinamon
Filmset in 'Monophoto' Univers by Photoprint Plates Ltd,
Rayleigh, U.K., who also reproduced the black and white
illustrations. Colour reproduction by Van Leer, Amsterdam,
Holland. Made and printed in the Netherlands by L. van
Leer & Co. NV, Amsterdam.

Library of Congress Catalog card number 78-109889

Contents

Artist's biographical note   7
The text   9
Notes   57
Selected bibliography   59
List of illustrations   63

Robyn Denny:

| 1930 | Born Abinger, Surrey |
| 1950 | Attended Académie de la Grande Chaumière, Paris |
| 1951–4 | St Martin's School of Art, London |
| 1954–7 | Royal College of Art, London |
| 1957 | Italian Government scholarship |
| 1957–9 | Teaching at Hammersmith School of Art, London |
| 1959–65 | Visiting lecturer at Bath Academy of Art, Corsham |
| 1965 | Visiting lecturer at Slade School of Art, London |
| 1966 | Appointed to Art Advisory Panel of the Arts Council of Great Britain |
| 1967 | Visiting professor at the Minneapolis Institute of Fine Art |
| 1969 | Instigated the organization of the Charles Biederman retrospective exhibition, Arts Council, Hayward Gallery, London |
| | Living in London and Somerset |

*One-man exhibitions*

| 1958 | 'Mosaics', Gallery One, London |
| | Gimpel Fils, London |
| 1961 | Molton Gallery, London |
| 1962 | Galleria Scacchi Gracco, Milan |
| | Galerie Müller, Stuttgart |
| 1964 | Kasmin Gallery, London |
| 1965 | Robert Elkon Gallery, New York |
| 1967 | Kasmin Gallery, London |
| | Robert Elkon Gallery, New York |
| 1968 | Renée Ziegler, Zürich |
| | Forum Stadtpark, Graz |
| 1969 | Kasmin Gallery, London |
| | Waddington Gallery, London, Print Exhibition |
| 1970 | Galerie Müller, Stuttgart and Cologne |

*Selected group exhibitions*

| 1953–7 | Young Contemporaries, London |
| 1957 | 'Dimensions', O'Hana Gallery, London |
| | 'Metavisual, Tachiste, Abstract' – Redfern Gallery, London |
| | 'Critic's Choice', Tooth's Gallery, London |
| | 'Six Young Contemporaries', Gimpel Fils, London |
| 1959 | I$^{ère}$ Biennale des Jeunes, Paris |
| | 'Place' – a collaboration, Institute of Contemporary Arts, London |
| 1960 | 'Situation', R.B.A. Galleries, London |
| 1961 | 'New London Situation', Marlborough New London Gallery, London |
| | 'Art of Assemblage', Museum of Modern Art, New York |
| 1965 | John Moores Liverpool Exhibition 5 |
| | 'London: The New Scene', Walker Art Center, Minneapolis |
| 1966 | Five Young British Artists, British Pavilion, XXXIII Biennale, Venice |
| 1967 | Edinburgh 'Open 100' Exhibition |

The painting is eight feet high and six and a half feet wide. Taller, in other words, than a man's head and wider than the span of his arms, but not so much so that size overwhelms him. It is a size which expands the measure of a man but still relates to it, particularly as the forms on the painted surface tend to be locked around a central image of roughly his own scale. Robyn Denny keeps to these dimensions in almost every picture he paints, and they are only marginally larger (larger by one 'beat', as it were) than those he used with comparable regularity up to 1965. They are clearly an optimum size, as the upright rectangular format is also an optimum format, which is essential to his purpose.

The spectator is faced by a flat, painted surface, virtually standing on the floor as he himself is standing, and confronting him with a system of balanced, enclosed, quasi-geometrical relationships which in some sense mirror ideal human proportions. 'Ideal' rather than 'actual', for the slightly larger-than-life scale in fact provides a dimension of the noble and the heroic. But it is a finite and inhabitable scale, which is partly why critics have been fond of using architectural images, particularly the image of the entrance or doorway, to describe the physical presence of a Denny painting. Of all parts of a building, the doorway is that which most precisely sets the standard of harmonious, man-scaled architectural proportion. It is not exactly man-size, but the size which frames with dignity the act of passing from one space to another.

It is necessary, even to the point of being pedantic, to emphasize these dimensions as a precise physical attribute. They are not only central to the effect, but can be seriously misjudged by looking only at reproductions. There are kinds of large-scale modern painting where the effect of size is potently physical but imaginatively relative: one gets the point by knowing it is *very* large. One needs to know *exactly* how large a Denny painting is. It is neither easel-size nor environmental, but anthropometric to a degree which is surprisingly rare even in the predominantly humanist tradition of Western Europe. Height and width provide external measurements for the painting as a physical object (one notes that for all its flatness, the painted surface is carried on round the edges of the canvas for the depth of the stretcher, confirming that it *is* an object). But equally important is the establishment within the painting of an eye-level. What one may call its principal 'events' depend on the relative weight one accords to things that make one look up at them, look down at them, or look them, as it were, straight in the face. What happens to left or right is less crucial. Like one's own body, the left side and the right are mirror-images of one another, and

therefore passive: they balance. The axis of involvement is vertical. We take our measure of the world by the act of standing upright in it and surveying it from a certain height above the ground.

Hardly less essential to a Denny painting than its scale is the actual quality of its colour. It is slow-working colour, which is to say that it demands time and awareness of time. This is not merely a matter of its being muted, shadowed or reticent, or of the eye's need to adjust to close-toned variations of hue. Since 1968 it has in fact become more brilliant, and to characterize it as somehow permanently twilit is no longer relevant. The point is that it requires to be seen (one could almost say 'watched') by natural light, which means not only daylight, but light which changes according to the time of day. Again, it is necessary to sound pedantic about what may seem an obvious necessity. European painting, and perhaps English painting in particular, tends to assume such viewing conditions. But they are in fact little more than relics of academic tradition. A great deal of modern painting neither gets nor strictly requires natural light. Denny's painting does. His titles sometimes remind one of the fact — *A Time* [1], *First Light* [28], *By Day* [34], *Time of Day* [36], *When* [37]. The paintings are colour-structures which change as the light changes, change as radically as if their formal structure had been altered. Time and the action of time are elements built into them.

Light and time have often been linked in the work of painters who are concerned, as Denny is, with the process of looking: Vermeer's held moment is as much about how they depend on one another as are Monet's hours of the day. In a Denny, though, they are agents of the way in which the painting works, rather than its theme. They allow for continuous shifts and changes of relationship between the various parts of a surface which would seem to have been organized against change. 'No painting', Denny has said, 'should reveal all it has to say as a kind of instant impact. Abstract painting, that is painting which is not about subject-matter, if it is any good should be as diverse and complex and strange and unaccountable, and unnameable as an experience, as any painting of consequence has been in the past.'[1]

At first sight a Denny painting hardly seems diverse or unaccountable at all: only a rather noticeable quietness suggests that anything is held in reserve. The painting makes no show of temperament except what can be read into its very avoidance of gesture or display. It lies open to one's gaze, as lucid and untroubled as only a composition that has been brought to a state of perfected harmony can be. The surface is beautiful in its stillness, translucent and

yet solid and rich as velvet. Within the surface, rather than on it, certain forms stand out as the shapes that the colours make as they meet, turn around or enclose each other. One is aware of a certain interlacing among them around the central area — bands that cross over or pass under other bands — but the general effect is a calm uncomplicated formality. The great framing arch and the flat panel down the middle of the painting supply images of' irreducible simplicity.

But as soon as one begins to enumerate like this what might seem to be reasonably unambiguous about the painting, the ambiguities appear. How dense, actually, is the colour, and how bright? It hovers indefinably between degrees of possibility. Imagine it in a slightly stronger light, and it would retreat into shadow. Imagine it more shadowed, and it would start to glow. Or to be more precise, some colours would shift tonally in relation to others, and once that started happening, the entire colour-structure could turn inside-out. The fact that the colours lie in one surface-plane is denied by the illusion that they lie in different planes, close-stacked, overlapping and folded one within another. Some continue to read as surface, some read as space, turning transparent as one looks at them (blue will always invite such a reading, and in *A Time* there are three different blues as well as a translucent lilac).

A shorter way to describe what happens is to call it optical colour-painting, which is art-criticism's method of short-circuiting experience by labels. Optical colour-painting simply means painting which exploits the capacity of colour to appear visually unstable and illusory in differing circumstances. Painters have always been aware of colour's optical behaviour-patterns, and science has tried explaining them in theories of visual perception. But in an abstract idiom their effects can be experienced for their own sake, freed of the necessity to describe other things. Colour then becomes a vehicle for recording, not abstract ideas (it is too sensual and, as Baudelaire said of it, too *visible* for that), but sensations and experiences which have no other material counterpart. It becomes a way of touching the intangible or seeing the invisible, and if such phraseology smacks of the metaphysical, that ultimately is what it has got to do: art that does less, doesn't do enough.

Some pure colour-painting invites the spectator to lose himself in the experience or the sensation as a whole — what Monet meant by calling one of his late 'nymphéas' paintings *Nirvana jaune*. A painting by Denny firmly but subtly refuses that surrender of self. It is capable of evoking mystery, but anchors it in an image which appeals to the ordering intellect and is brought within reach of our

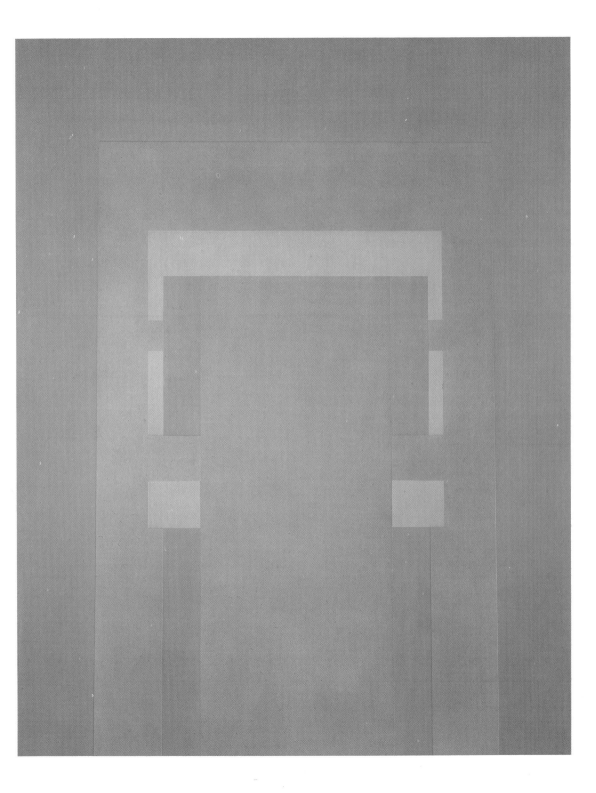

own physical scale. Lucid, unemphatic, symmetrical, it is about preserving a certain necessary balance within us between the claims of the knowable and the unknown.

Denny was a student during the first crucial decade that followed the ending of the Second World War, and most of the convictions which have given his art its exceptional inner logic and consistency were formulated during this period. It was an opportune period in which to be coming fresh to the problems of what painting and being a painter meant. Britain had been seriously isolated in artistic matters during the war, and when it ended, the first thing that British artists needed to do was to look around, take stock, find out where they were, and start afresh. It was a period of uncertainty and diffidence, but also of energetic self-questioning. Paris seemed, as it had seemed for so long, the probable source for the more authoritative new thinking that had to be done, but there were doubts about that too. In the event, the doubts were to prove justified.

In January 1956, in the last room of the 'Modern Art in the United States' exhibition at the Tate Gallery, a major group of American Abstract Expressionist paintings was seen for the first time in Europe. Exactly three years later, the 'New American Painting', also at the Tate, confirmed that a profound re-orientation had occurred: the most advanced and serious painting in the world was coming no longer from Paris, but from New York. In any discussion of post-war British painting, these two manifestations tend to crop up as moments when the tablets of the law were brought down from Sinai. They were indeed crucial events, and the American influence has been enormous, liberating and undeniable. The effects of an Anglo-American dialogue are already part of the history of painting in the late fifties and early sixties, and they are of central relevance to Denny's art because Denny belongs to the first generation to come to maturity under the new order, and also because he has necessarily been concerned with what it means to forge a new definition of 'being British' in a period of American ascendancy.

Nevertheless there tends to be an assumption that before these revelatory events British painting was irredeemably provincial and backward, and that overnight it started to grow up. It would be truer to say that the arrival of the Americans provided evidence of a breakthrough for which many British painters realized they had been waiting and, to some extent, preparing. It confirmed, crystallized, lent authority and gave a lead to certain convictions about the future of painting which were already in the air. To be a student during this period (Denny was three years at the

St Martin's School of Art from 1951, and then at the Royal College until 1957) was to profit – not from the teaching, which was out-of-date and irrelevant – but from a sense of being in at the beginning, when painting was ready to be invented all over again, and it seemed that anything was possible. American influences were predominant, but they were part of a complex process. They brought a revelation of what unprecedented size, total commitment to the act of painting, a new kind of pictorial space and a new emblematic kind of abstract imagery could mean, and they fell on prepared and fruitful ground. The viability of pure abstraction was in Britain, as elsewhere, still a burning issue. The whole basis of modern painting was under debate, and being subjected to intense critical re-examination.

In 1957, Denny's last year at the College, two exhibitions in London took stock of the debate and of what British abstract art had achieved since the war. One was 'Statements' at the Institute of Contemporary Arts, the other 'Dimensions' at the O'Hana Gallery, and both were organized by Lawrence Alloway, the most perceptive and best-informed critic in the country on *avant-garde* tendencies. It could be seen that after a slow beginning, when it was little in favour, abstract art had gradually been winning adherents among many of the best and most serious British painters, and gathering momentum right up until 1956, which Alloway considered the triumphal year for 'informalism', when 'everybody got into the act of painting'.[2] There had even been some significantly early starts – Victor Pasmore's spectacular espousal of abstraction in 1948; Alan Davie's awareness of Pollock in the same year. And it is worth noting that in 1950, when Denny was in Paris for a short time after completing his national service in the Navy, he had joined Neil Noland (the brother of the American painter) in experiments which only later could be seen as a kind of spoof anticipation of action painting.

Two dominant tendencies of the time, the 'geometric' and the 'painterly', had each in the first place reacted against the accepted conventions of the 'easel' picture, and each occasionally overlapped the other's province. But for the most part they were mutually opposed, one line of thought leading by way of an interest in mathematical proportion to a revival of that dream of Mondrian's in which art and architecture in the service of society would create the fitting 'environment' for a modern world: the other enlarging on the significance of the artist's personal, creative gesture, the autonomy of his material, and the virtues of improvisation. The extremes were represented by, on the one hand, an intelligent but rather inhibited constructivist movement and,

on the other, by a rather sloppily unconvincing *tachisme* of Parisian as well as American inspiration, and in the middle a fine old British compromise was achieved in 'allusive abstraction', reluctant wholly to abandon references to nature or some sort of figurative imagery, and mainly exemplified by painters grouped together as the St Ives School.

Denny was a *tachiste,* or more accurately, his idiom was of an informal, gestural kind. To one of his generation, abstraction as such was fairly obviously the language for a young painter to use: he was spared the earlier, agonized debate about its validity which some of his older contemporaries had had to face. Even as a student, he used it with instinctive confidence, and his work attracted notice at the 'Young Contemporaries', the annual student show which was rapidly becoming an important barometer of how the new tendencies were progressing. In 1957, when he exhibited there for the fourth and last time, he also had a painting in 'Dimensions' and was represented in no less than three other exhibitions in London devoted to recent developments.

He was at a stage when he was clarifying two linked preoccupations in his early painting, one leading through gesture and signs to his murals of 1959, the other towards his 'transformable paintings' and the exhibition 'Place' in the same year. With the two contemporaries at the Royal College who were closest to his own way of thinking, Richard Smith and William Green, he had, as Alloway noted, 'spontaneously developed a free painterly style in opposition to the staff and the indifference of the rest of the student body',[3] and the vital point was that it was a style which had been developed and not a style by which he had been seduced. Much of the interest in *tachiste* and gestural idioms around 1956/7 had concentrated on a kind of slap-happy informalism and the pleasures of exploiting pigment and brush-strokes for their own sake. Denny was a gesturalist, but he was quite clear that abstract painting was not about paint in the abstract: it was about meaning expressed in abstract imagery.

He had produced at the Royal College a thesis called 'Language, Symbol, Image', which had as its sub-title 'An Essay on Communication'. Neil Noland had introduced him to the poetry of E. E. Cummings, and he had found in Cummings's use of syntax and language a clue to something of what he wanted now to argue out in terms of painting. One particular aspect of the essay was concerned to explore the relationship between precise meaning and free physical action through the language of sign and gesture: it ranged in reference from graffiti, street signs, Times Square and the French 'St Raphaël' apéritif advert,

to Chinese calligrams, a llamai musical score and Tibetan edible charms. He had also done some typography at the College, and lettering, transformed by or into gestural activity, became the main 'abstract' vehicle in his painting both for extra-visual associations and the kind of references to reality for which one finds them used in early cubism, Schwitters, or Stuart Davis, an American painter he early admired. At first his aim was to retain these associations and references only as a kind of submerged presence within the work; writing was buried or obliterated within the paint: (in his thesis he had instanced walls on which scrawled slogans were so thickly overlaid that they had acquired a new type of meaning — undecipherable in the original, but still potently 'messages'). The paintings were dark and liquid and predominantly *tachiste.* Characteristically they dissatisfied him as being too free and lacking in visual clarity. He turned to collage and stencilling as intermediaries between random technique and precise form [2], and then, more as an experiment than anything else, tried heightening his colour, the clarity of his forms and the physical actuality of his medium simultaneously by embedding mosaic in thick runs and agglutinations of pigment.

It was with these densely built-up mosaic-paintings — 'landscapes, really', he has called them — that he appeared in his first one-man show, at Gallery One, in January 1958. Mosaic interested him, like collage, as being a medium in

2. *Painting 17,* 1956

3 (opposite). *Maquette for Austin Reed mural,* 1959

which one could make shapes change their function, and even their identity, by swapping them around in altered contexts, and the two techniques led directly to his murals of 1959 for Austin Reed's shop in Regent Street and the London County Council's primary school at Abbey Wood. In both these works, lettering or figures emerge from being referential clues to being the entire image. At Austin Reed's the management asked for a trendy evocation of fashionable London: what after some demur they accepted (the finished mural differed slightly from the maquette) was a metropolitan landscape by the 'St Raphaël' advert out of Stuart Davis, an abstract Pop Art of urban imagery [3]. But the Abbey Wood mural is both perceptually more complex and a closer anticipation of Denny's later painting. It is full of clues, puzzles and transformable passages, legible as shape or letter or the beginning of word-formations, and it is significant that image and ground have become already interlocked and virtually interchangeable [4].

Side by side with this development went another, starting from related preoccupations but leading to different results and culminating in 'Place' at the Institute of Contemporary Arts in September 1959. 'Place', which was a collaboration between Denny, Richard Smith and Ralph Rumney, was about a good many things, but one of the most important concerned making art intelligible by making

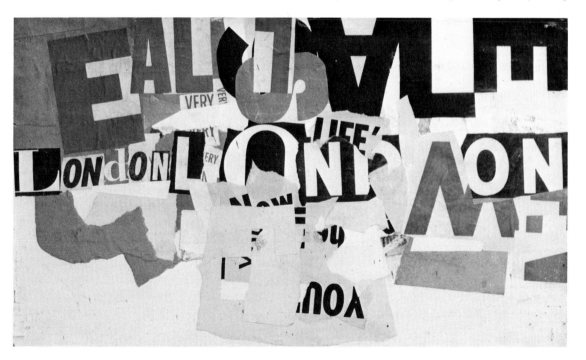

it happen in an understood context. Modern art, and abstract art particularly, has always been accused of being too hermetic for general consumption (an ironical accusation because it has usually been abstract art which has striven hardest to close the gap between the artist and society, and figurative art which often widens it by clinging to the idea of a 'private vision'). This was a subject much debated within the Royal College and at I.C.A. discussions.

British constructivism, by aligning itself with architecture, was already a bid for art with a public role. But it was being argued that the gap might be narrowed in quite a different way. Common ground between the artist and his audience could possibly be found in an understanding of the psychology of city life, the role of the 'consumer', his conditioning by the spread of mass media, the workings of communications systems and information-theory.

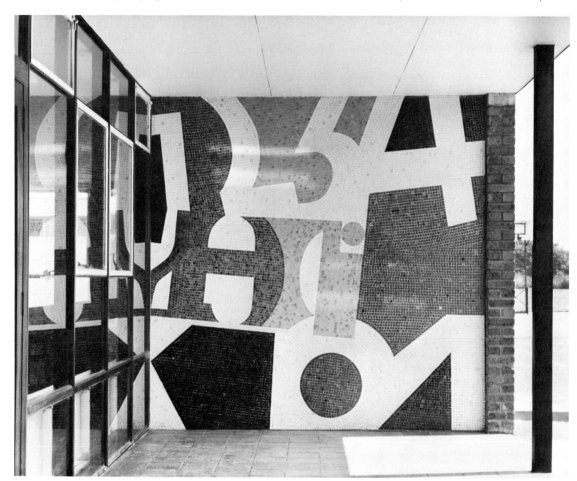

4. *Mosaic mural*, 1959

5 (opposite). *Transformable 1*, 1959

The need was to make art correspond, if only by analogy, to the communal experience of society. It was a need answered in one way by Pop Art, which adopted the relatively undemanding solution of collaging together readily accessible images of metropolitan living. The earlier and tougher reaction was to find a solution through abstract art. The line of thinking which found practical expression in 'Place' (aspects of it had already been explored in two other collaborative and environmental exhibitions, 'This is Tomorrow' in 1956 and 'An Exhibit' at the I.C.A. in 1957) was summed up some time later by Denny in a word with which he headed an article for the broad-sheet *Gazette* — 'togetherness'. It was an article about bringing art into the public sphere by collaboration: collaboration between artists (shared interests and aims) and collaboration between the artist and the spectator/

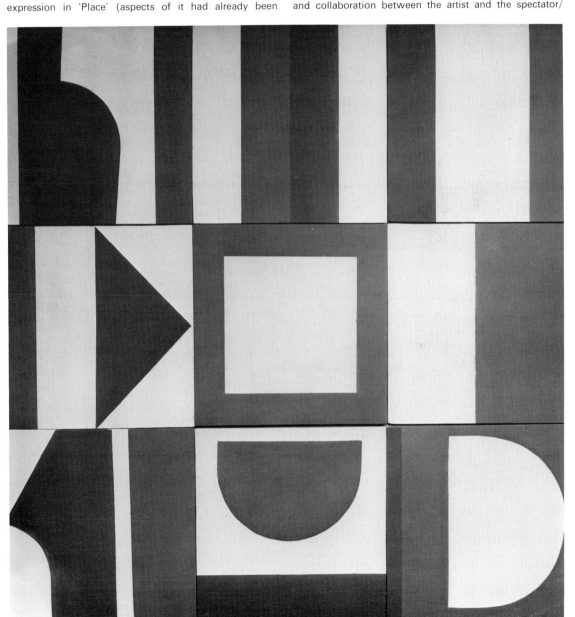

consumer/audience (shared experience). Togetherness implied the bringing together of all participants in a context which was controlled, but in which one was still free to influence the final result or the final experience according to one's degree of involvement.

A purely aesthetic application of the idea had been his own 'Transformable Paintings', described in the *Gazette* article as 'studio art en route to public art: artist as audience: elements to be separated and re-assembled permitting diversity of interpretation' [5]. A wider application con-cerned the bringing together of the artist's pictorial space and his audience's 'real' space, and setting up a dialogue between them. It was a question of linking two worlds, the world outside the painting and the world that was re-created, as it were, inside it. *Living In* [6] was for Denny a crucial step towards involving the spectator by means of a scale and a physical presence which seemed to belong in the same kind of space as the spectator himself — a space for 'living in'. *Home from Home* [7] was a logical pro-gression from it, the first of Denny's paintings actually

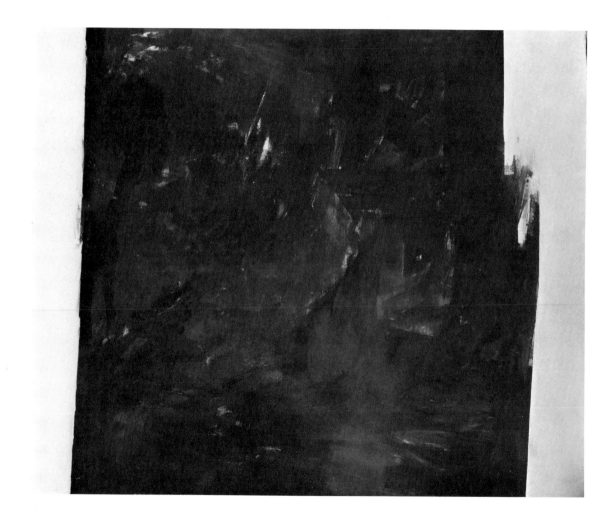

6. *Living In*, 1958–9

7 (opposite). *Home from Home*, 1959

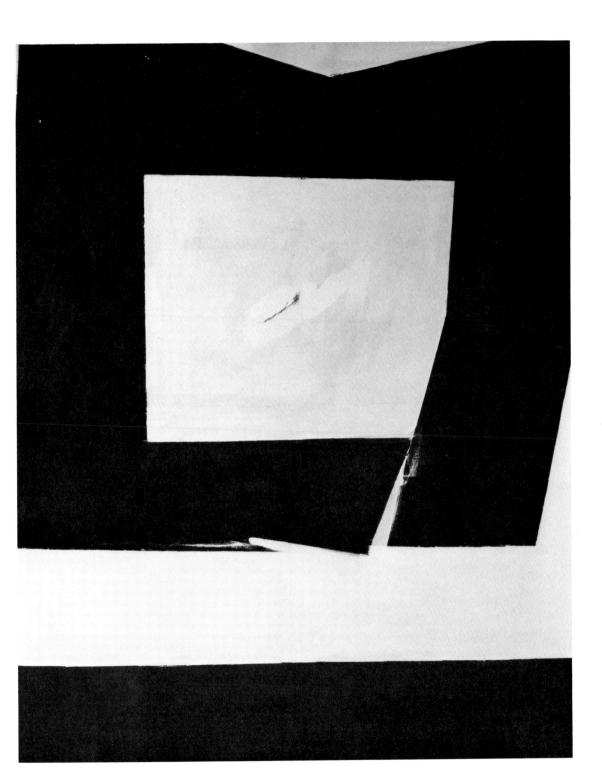

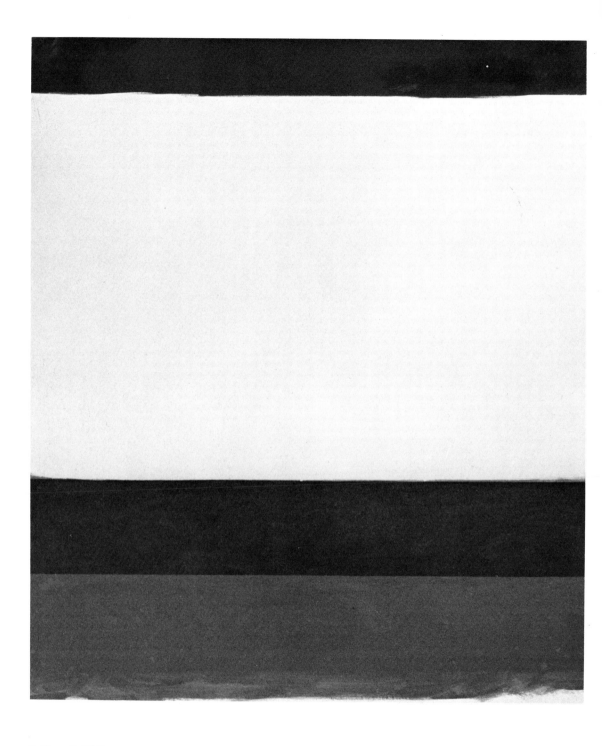

8. *Place 3,* 1959

to stand on the floor, with a broad band at the bottom like an invitation to step through from real space into pictorial space, and a title to emphasize that one was an analogy of the other. This broad band, the 'step-in' or 'threshold' to the world of the painting, was the first intimation of something which has remained essential to all Denny's work. It was the painting's invitation to the spectator to feel a connection between real life and a kind of symbolic life which the painting makes accessible (the idea of *Home from Home* turns up again several years later when Denny used titles from *Alice in Wonderland* to suggest the stepping-through into that other life). The full implications of 'togetherness' were attempted in 'Place'. Very large, 'man-size' canvases by three different artists, of standardized dimensions and colours (red, green, white and black) were arranged to form corridors and vistas whereby the painter's space interlinked with the viewer's [8, 9]. It was a collaborative enterprise: the spectator was obliged to

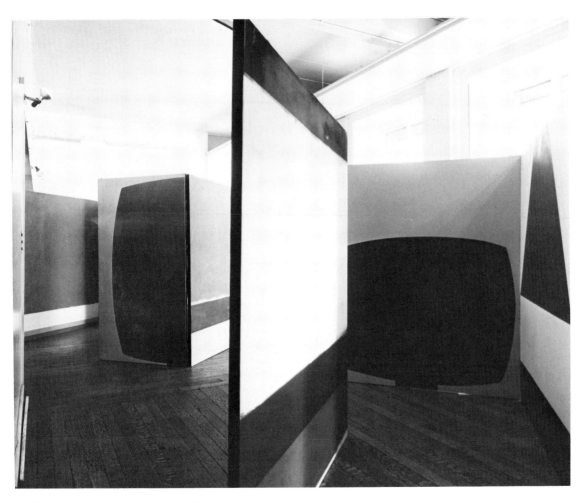

9. 'Place' — installation shot of the exhibition at the Institute of Contemporary Arts, Dover Street, London, September 1959

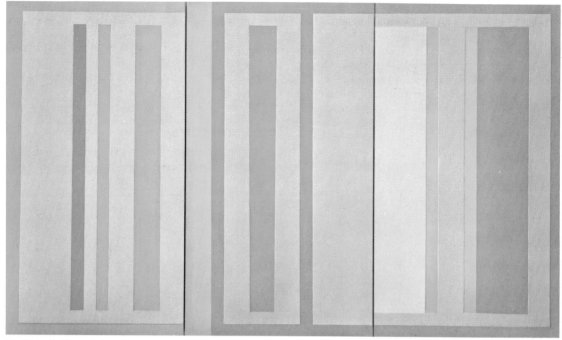

10. *Baby is Three* (triptych), 1960

become a participant: and he could interpret what he saw according to where he chose to stand and in what direction he looked. The exhibition appeared to many people at the time to be American-inspired, although in fact it was about specifically British preoccupations (American painting was in no sense concerned to be communal): the point of it was almost totally missed.

The internal logic of Denny's early development, characterized as it was by intellectual engagement on a wide front, outwardly appeared as rather startling shifts of style. There appeared to be another shift in the paintings of 1960 and 1961, but in fact all the issues with which he was involved were now coming together in the beginnings of his mature manner. In September 1960 he was represented by three paintings (including *Baby is Three* [10] and *7/1960* [11]) in the 'Situation' exhibition at the R.B.A. galleries. *Baby is Three* is for Denny a key picture, but before discussing it one needs to pause at that now evocative, historical name, 'Situation'. It was itself a key exhibition in the development of post-war British painting. A new generation was seen to have come of age, and it had a new, positive identity. 'Freedom and confidence', as Alloway wrote at the time, 'have followed, grown out of, the period of American dependence.'4

'Situation' in retrospect, however, has been interpreted as a good many things which it wasn't. It wasn't, for example, either a platform or a launching-pad for any specific style, dogma, movement or group. It was about the existence of an important mainstream 'situation' of large-scale abstract painting in London, irrespective of idiom or affiliation. In particular, it was about the concept of the Big Picture, as introduced by the Americans. Among the twenty participating artists there were as many styles. But in the last room at the R.B.A., always in effect the 'climax' of exhibitions there, had been hung the mainly formal, 'Hard Edge' and relational paintings, Denny's new ones among them, and it was with these that the name 'Situation' promptly became identified. To the critics and the public they were a newer and even tougher phenomenon to take than gestural painting had been, and in them the general issues of size and formal simplicity of image seemed to make an impact more memorable than in the rest of the exhibition.

Denny again was centrally involved: he was the exhibition's organizing secretary. 'At this time', he wrote later, 'I was experimenting with what new sensations of colour can be achieved with the most limited means — what great diversity of formal experience I could make with very

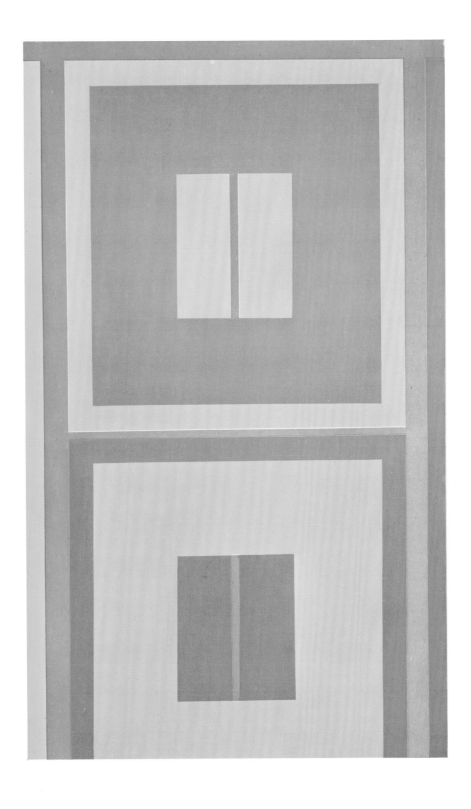

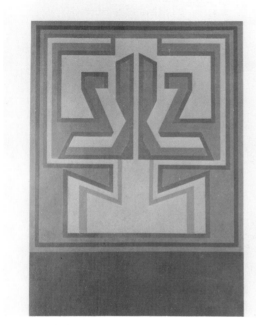

12. *Frontman*, 1961

13 (opposite). *Wardrop 1*, 1961

achieved by a straightforward colour-reversal which makes the picture look strong but schematic. But in *Baby is Three* this optical approach becomes more complex, authoritative and grand. Each part of the triptych is self-contained, but the assertive reds swell forward and yield place in turn in a steady, cumulative beat from left to right across the full width of all three panels.

Optical painting as such had barely been considered as a viable idiom at this time (Bridget Riley held her first show the following year) and to Alloway the picture was just 'a never-ending fidget with clashing colour'.[6] But the title reveals a little more of what Denny was really after. It is taken from a science-fiction story by Theodore Sturgeon in which a community of the blind, the deaf and the crippled pools its limited physical resources and finds that each has become so highly developed and specialized to compensate for handicaps in other directions that together they add up to unprecedented physical power. Denny's triptych is about maximum power from limited means, and about the whole being more than the sum of its parts.

Two kinds of theme begin to emerge in the paintings of the following year, 1961, or what might more accurately be called two kinds of felt presence. Some paintings, that is to say, *felt* like places, and others *felt* like people. In the first group it was as though some of the environmental experience of 'Place' were being re-interpreted in two dimensions, as ground-plans or aerial views. The painting was itself a 'place' where the eye experienced the physical and psychological effects of exploring its way around, finding puzzles and having to make choices. At Corsham, where he had been teaching since 1959, Denny had worked with his students on the concept of mazes. It was partly a games-situation, with roots both in 'Place' and the earlier transformable paintings, but considered more strictly as a perceptual activity: colour even more than form now effectively controlled a play of alternative readings, a maze-like interaction of through-routes and cul-de-sacs, entrances and exits.

At this time Denny always worked out the entire painting on the canvas itself, with whatever that involved of changes of mind or complete re-painting or the overlaying of one solution by another. Hence the title *Frontman* [12] for a painting which confronts the world, as it were, with a mask that both conceals and is the product of its own inner history. *Frontman* and *Wardrop 1* [13], one of Denny's most powerfully archetypal images at this period, are both pictures that 'felt like places'. But in pointing out how their scale implied 'an ambience of human use', Alloway also found in them analogies of such forms as a control-board — images one might reach out to and measure by.[7] Tech-

limited forms.'[5] His three paintings exemplified an effect which Roger Coleman, in reference to several artists, described in the catalogue as 'cartographically simple but perceptually complex — a kind of stable/unstable surface'. In *Baby is Three* [10] the most significant achievement is that within a surface held impregnably together by almost tactile paint, by hard colour and by total interlocking of image and ground (in so far as image and ground can in fact be distinguished from each other), there is a continuous shift of spatial readings between one band of colour and the next. In *7/1960* [11] the effect is more crudely

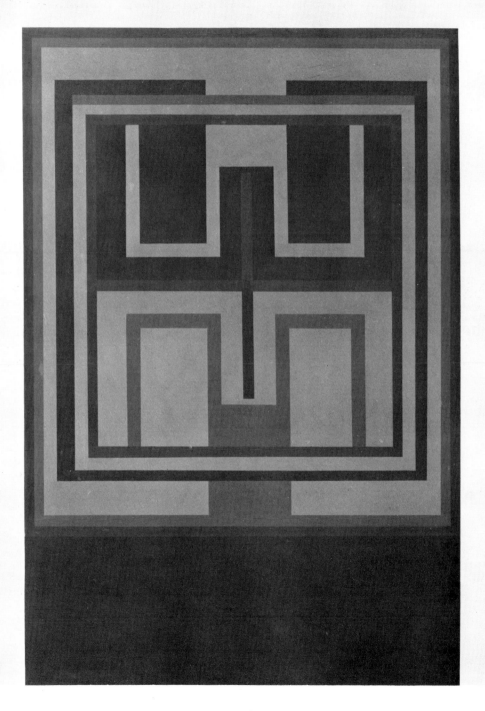

14. *Track 4*, 1961

15 (opposite). *Gully Foyle,* 1961

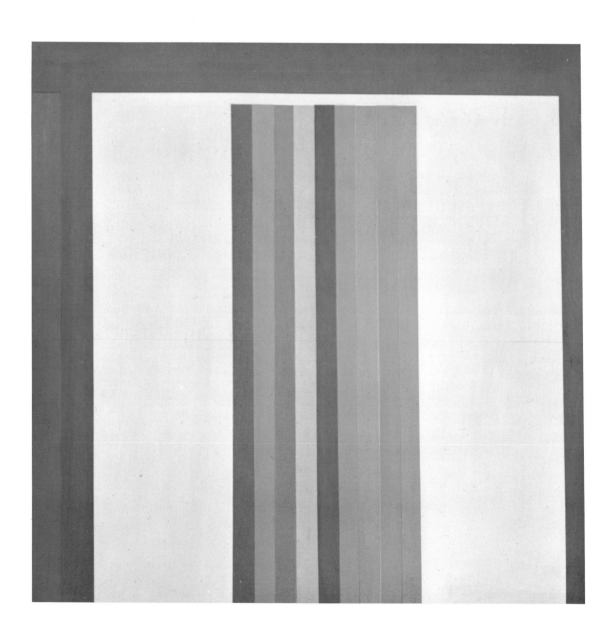

nically *Wardrop 1* (the number has stuck, although in fact there was no series) is a subtler variant of the colour-reversals in *7/1960*, and its name is that of the author of a work on visual illusion. And like *Frontman,* it keeps the dark 'step-in' slab along the base of the main image, which had been the spatial link between picture and spectator in the paintings for 'Place'.

This step-in slab is the first feature to disappear in the paintings that 'felt like people' [14]. The central form now reaches down to touch the floor, and the containing bands of colour no longer surround it but step back to frame it as by an arch which is also its habitable space. It is first and foremost a standing image, man-height. Or to distinguish it more precisely from what happens in *Frontman* or *Wardrop 1,* one might say it is not a face but a figure. A face, in whatever applied sense one uses the word, is a pattern of features, a map of internal related incidents which add up to an overall expression. A figure is something seen from

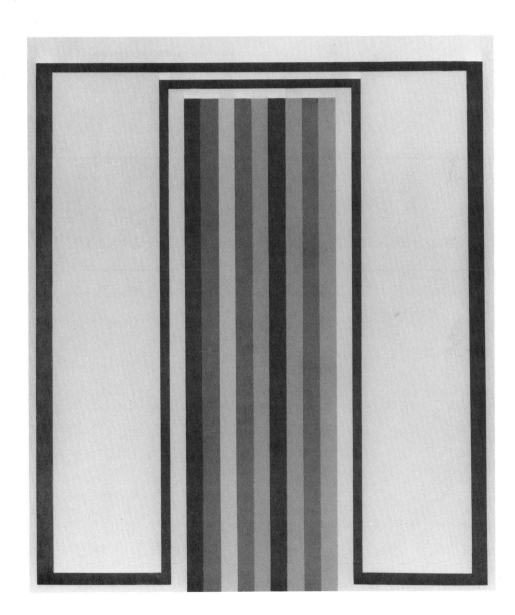

further away and in relation to some kind of surrounding context, so that it becomes a separate and self-enclosed entity. That, at any rate, is the distinction that Denny introduces in the main imagery of such paintings as *Track 4* [14] or *Gully Foyle* [15]. A solid-seeming slab of colour-progression, close-packed and close-toned, is held within a virtually open field. Weight is balanced by lightness, a condensed statement off-set by a featureless environment. And now the full implications of the band of light blue that first appeared round *Frontman* are developed. A 'container' had been needed for the central form which would separate it from the surrounding wall and establish it in a space of its own. Two things happen as a result. The whole configuration *suggests* proportions on the grand scale, almost without reference to the picture's actual size: the connotations of an architectural image have made their appearance. And the containing space becomes just that — space: open, vacuous and illusionistic.

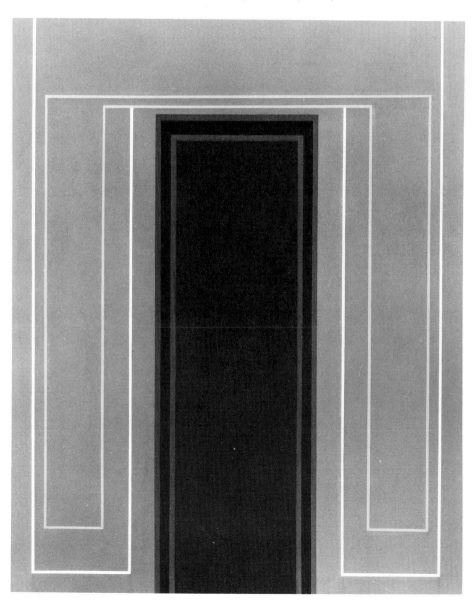

16. *Out-Line 5,* 1962

A kind of moral imperative to avoid or at least minimize the effects of illusionism has haunted most of the history of abstract painting. Illusion and the primacy of the flat surface are, logically speaking, mutually exclusive, and much of the theory of modern art is argued out on a basis of logic ('painting deals with two dimensions and *therefore* should not suggest three'). In practice, the fascination of painting as an art has continued to be that it is not logical. It lacks the extra dimension to be an art of the real and remains inherently an art of metaphor. Faced with the problem of activating a flat surface, the painter must needs either write (that is, work through gestures, signs, emblems or symbols) or recognize the claims of illusion.

Denny had explored gesture, signs, certain effects of pictorial space and certain effects of optical illusion. He was now concerned with the illusion of space. Sometimes it is daring to be obvious, and there is an obviousness about the blue he now used and about the role it plays which is so literal that in context it strikes one as poetic. That it can do so is the effect of an otherwise barely definable aesthetic 'rightness'. The paradox had to be sustained between illusionistic space and the skin of the painting, so the chosen blue was sometimes deliberately intensified to keep one aware that it is paint *applied* to a surface, not just the sky. But one notices that it is in these paintings that Denny's colour as a whole begins to lose its earlier opaqueness and density. It becomes subtler, paler, more translucent, openly flirting with the atmospheric possibilities of the kind of space it is suggesting. Tension is still held at the surface, but it is held there now by a close organization of tone rather than by any feeling that the colour is solid. One can look *through* it or one can look *at* it. One can bring to it one's experience of real space or one's perception of it as symbolic space — as always in Denny's painting a 'games' situation of participation and choice is involved. A title like *Gully Foyle* [15] is another science-fiction reference; the name of an astronaut who got lost in outer space, a human consciousness measuring itself against the immeasurable.

The paintings of 1962–3 that develop out of this image are the ones in most critics' minds when they talk of Denny's imagery of closed doors [16, 17]. The idea is inevitable, given the scale and the shape, but it gets in the way. These continue to be 'person' images, differently articulated. The component elements remain the same — a central 'slab' and a containing 'space'. But the colour is condensed in range and unified by tone, giving a restrained near-monochrome impression, while the main energy of the surface becomes linear. Linear circuits, like internal and external nervous systems, distinguish between an inner

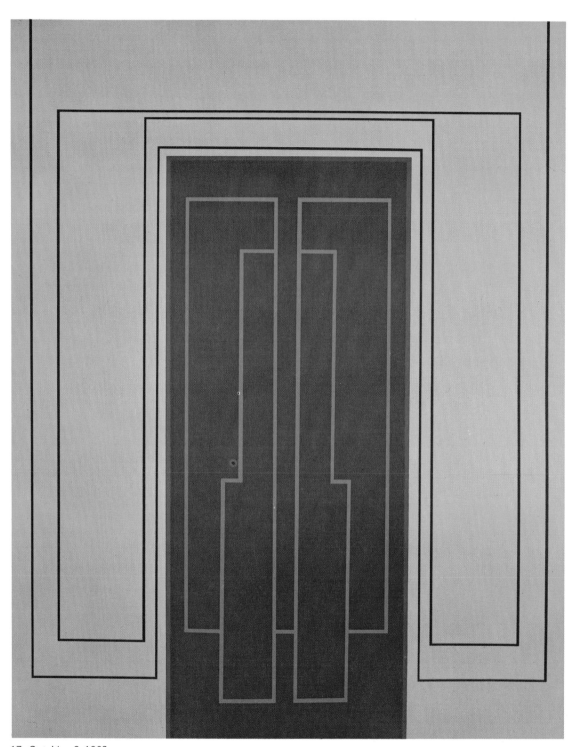

17. *Out-Line 3,* 1962

and an outer area of the painting, making them different in kind but perceptually linked, separate but interdependent. One sees maze-situations developing again. In retrospect, however, these paintings for all their accomplished elegance tend to look transitional. *Life Line 1* [18], which comes at the end of this linear period, shows what it was in fact pointing toward, which is not so much an interlacing of lines as an interfolding of planes. The up/round/down/ through movement is slowed down and locked in

position. Overlappings and hidden continuities occur (like the outside of one band that reappears as the inside of the next). Colour bands or colour areas are turned inside-out on themselves. One is reminded again of earlier colour-reversal procedures. But now there are hints of a much more complex spatial ambiguity.

In *Life Line 1,* however, the lines themselves are still unbroken and continuous, so that one's awareness of the painting's spatial organization remains secondary. But in

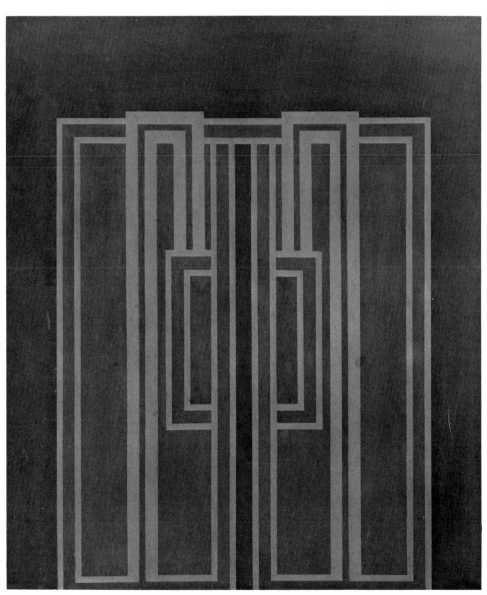

18. *Life Line 1,* 1963

19. *Jones's Law*, 1964

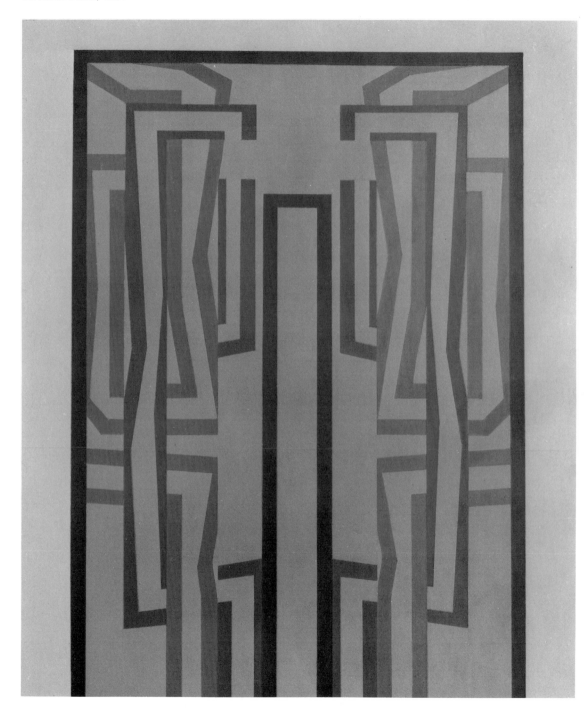

*Jones's Law* [19] of 1964 the strict linear mould is broken, and a new organization by planes starts a sequence of configurations during this and the following year which stand out almost eccentrically in the studied resolution of Denny's usual verticals and horizontals. Hidden within *Jones's Law* is a set of diminishing rectangles whose edges are at times invisible but can be deduced by sudden cut-offs and obscurings of continuity. The surface for once is not divided laterally in bands, but divided into shapes where each edge suggests the overlap by one plane of another, and though there is still the appearance of a strong linear activity, the painting only makes perceptual sense as an illusion in depth. This illusionistic 'flat depth' quality becomes even more pronounced in related paintings like *Connections* [20] and *Secrets* [21] where line as a visual direction-finder almost vanishes, and leaves the eye searching among shapes which may be parts of the continuous planes it keeps trying to discern or may be the spaces between planes that have become transparent. Positive forms and negative spaces change roles: the spaces *are* the positive forms and the spaces left between planes that have disappeared *are* the lines.

This perceptual hide-and-seek is carried to a pitch of ingenious gamesmanship which makes the paintings of this period the most 'busy' in Denny's work. They are, in both senses of the word, a kind of sport of relational painting (the title of *Jones's Law,* for instance, is a light-hearted reference to having read Owen Jones's *Grammar of Ornament,* a Victorian work which begins with a set of maxims about the relationship of ornament to society, to style, and so on). Not the least of their eccentricities is the introduction, for the first time since *Frontman* [12], itself something of a sport among the paintings of 1961, of slanting or diagonal directions. From Seurat's theories of perception to Van Doesberg's quarrel with Mondrian, lines at variance with the hieratic vertical or the restful horizontal have been taken to represent dynamism or vivacity, and in these paintings there is, for Denny, an unusual effect of movement and even speed. In *Jones's Law* this is controlled by the firmness of what remains of a linear grid. In *Connections* a fragmented, centrifugal movement in the main panel is held in check by the exceptional width of the surrounding border and the exceptional illusion of vacant space conveyed by the border's paleness of colour. In *For Ever* [22] the image is wound in on itself to become a meandering *perpetuum mobile* where movement can both continue and yet be brought to rest. It is an image of great poetic mystery, the *yin-yan* symbol of eternity rendered in shades of blue, green and yellow so close-toned and so close in hue that they seem endlessly to elude precise definition.

*Connections* and *Secrets* were transitional development-paintings, both radically transformed in the actual process of painting. Most of Denny's work, in spite of the smooth perfection of its surfaces, still carried at this time traces of the earlier evolution of the picture beneath the final skin of paint. It was a relic of his practice since his first gestural painting, but it was also part of the ethic inherited from Abstract Expressionism. That ethic required a painting to be the total record of the painter's creative process. Radical movements generally demand a radical morality, and in an art which had begun by emphasizing the primacy of the creative *act,* it was the painter's obligation to commit himself to every mark he made on the canvas. Initially, perhaps, this attitude had arisen out of a need to preserve immediacy and directness of statement, but it was also a rejection of the academic tradition of carrying out the groundwork of a painting not on the canvas itself but in preliminary sketches and studies. Central to all modern painting is the argument that a picture has its own inviolable rights to self-determination: that shapes, colour, scale and image can only be brought to that state of inevitability and 'rightness' which is the painter's ultimate objective if at every stage of their evolution their own laws of organic development are scrupulously respected. To a painter these questions virtually become questions of personal conduct and personal probity. Perhaps because, more than in any other art, what he produces is the physical trace of his behaviour over a certain period, for every nuance of whose final realization he is answerable to nobody but himself, the painter's commitment to his painting becomes an expression of what Denny has called an 'inner morality'. It may not (perhaps it cannot) mean very much to the viewer except in his instinctual response to quality, but it matters profoundly to the artist.

The point is that around 1965 Denny began to modify his working procedure. Instead of over-painting when alterations were necessary, and so preserving the picture's history within the canvas, he started again on a fresh canvas and carried on from there. Technically, of course, this was becoming imperative as the subtleties of his colour demanded immaculate purity of surface: the delicacy of the balance between surface-tension and spatial illusion could be upset if *pentimenti* happened to show through, and the skin of his paint was no longer opaque but more like a translucent membrane. It would in any case have been somewhat pedantic to insist indefinitely on retaining the same canvas throughout in an idiom that was not about

20. *Connections*, 1964—5

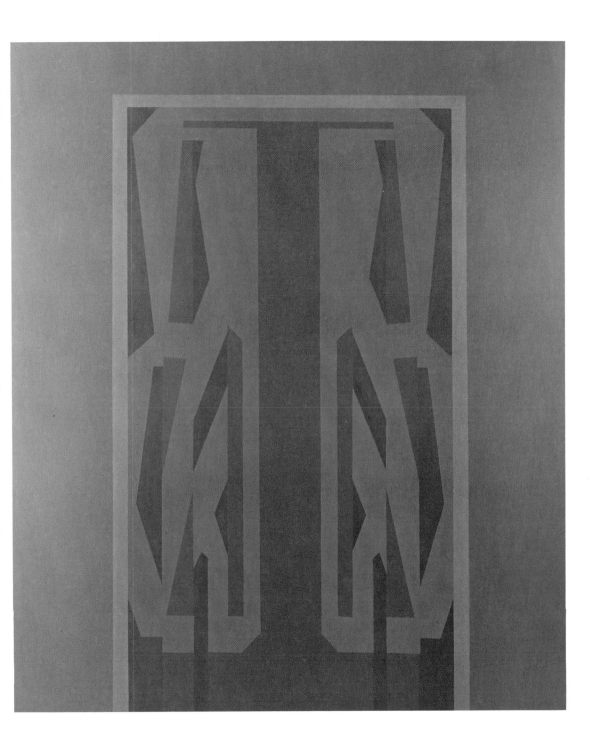

21. *Secrets*, 1964–5

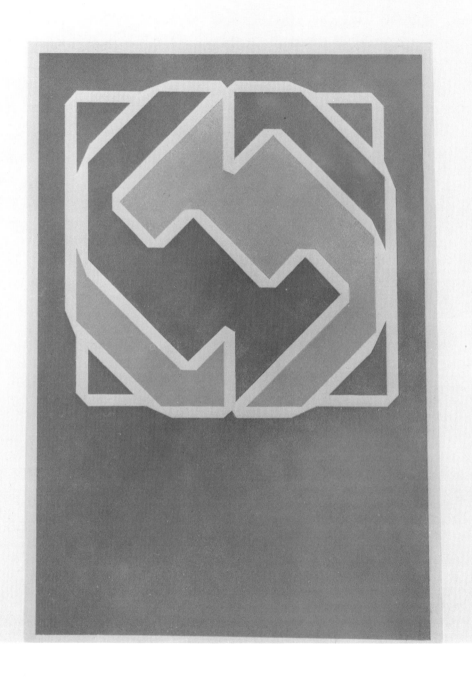

22. *For Ever*, 1965

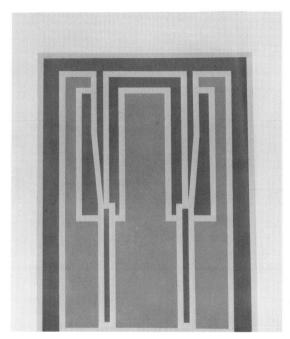

23. *Shade 2*, 1964—5

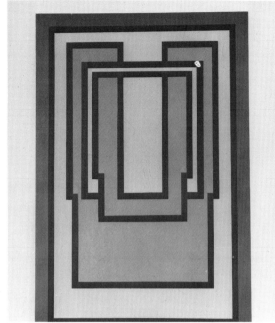

24. *Into Colour*, 1964—5

process but about the final perfecting of an image. Nor was any sacrifice of 'inner morality' involved. Denny's procedure was still essentially different from the classical academic method of designing first and executing the design afterwards. It was as organic as any gestural painting, and only differed from it in the strict formality of the gesture. This is the sense in which it is totally misconceived to think of his painting as having anything to do with 'geometric art'. He has never used a modular nor any system of mathematical proportion, but proceeds by pragmatic judgements and a commitment to what happens on the canvas in the actual painting of it. Pictorial decisions have to be *worked* towards their own resolution, never predetermined.

*Shade 2* [23] and *Into Colour* [24] are paintings in which one sees the beginning of a process of formal simplification. Something of the measured rectangularity and linear quality of *Life Line 1* returns. The perceptual punning vanishes, and where there does remain any illusionistic alternation of readings between different planes, the planes are kept enclosed within solidly defined edges and are clearly separated out one from another. What is perhaps most marked in these paintings, and continues right through to the work of 1967, is that the

growing simplification of the image is accompanied by a more even, sturdy thickness of line (line, moreover, which keeps to itself as a band of colour and doesn't open out into some other kind of colour area). And there is a pushing upward or pulling downward of the painting's main weight. In *Shade 2* or *Into Colour* it is a pushing upward: not just a suspension of the central image at eye-level, as it was in *For Ever* [22], but a definite anti-gravitational thrust emphasized by the way the forms arch over at the top or depend from the top, and are kept up there by thinner supports below. A similar distribution of weight continues through *Stand Point* [25] and *Dumb* [27] in configurations that even remove differentiation-by-colour from the various planes of the design, and apparently leave them to be defined by line alone. In fact they make the *exact* quality of the colour, poised at some indefinite mid-point between tone and hue, even more vital to the way one reads the painting. One starts to imagine, in the enclosed shapes, colour-differentiations that aren't there. With its extreme spareness, *Dumb* in particular is a thoroughly elusive picture. It earned its title by a certain bland quality of what Berenson called ineloquence, giving out no message but that of its existence.

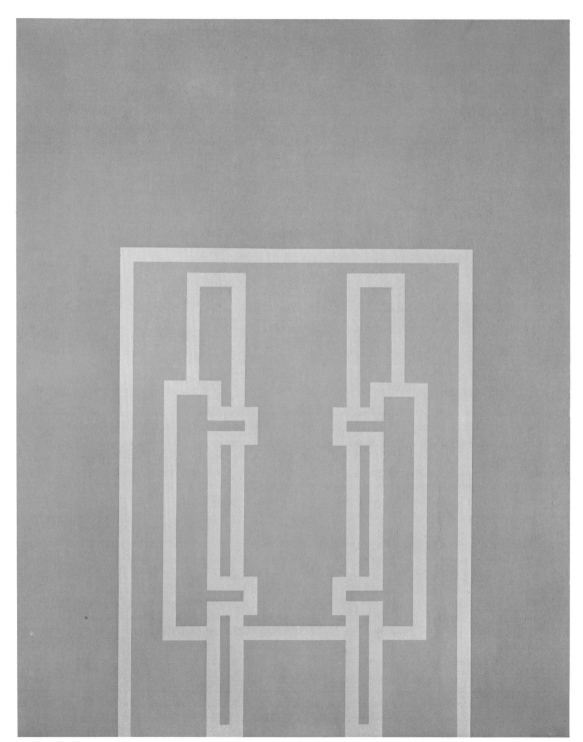

25. *Stand Point,* 1965–6

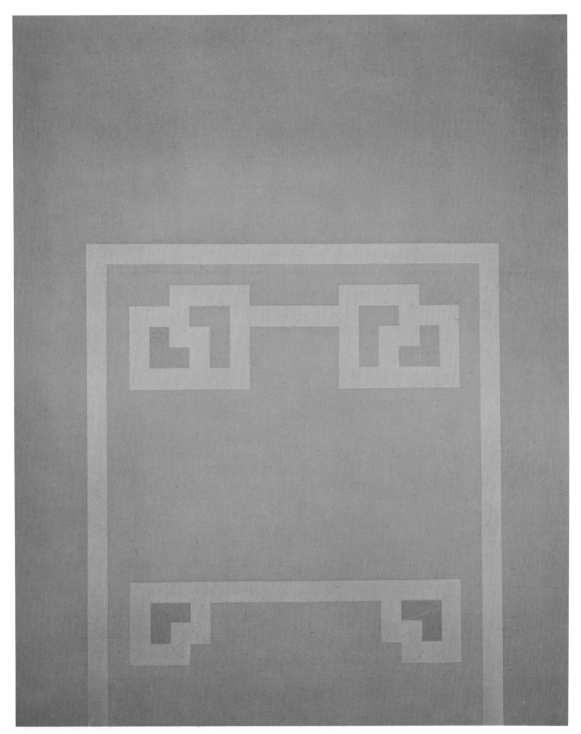

26. *Go Between*, 1964–5

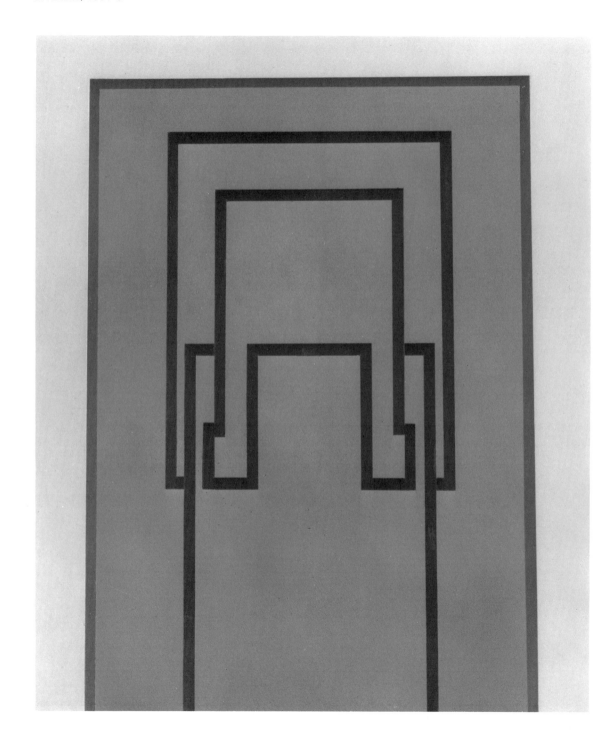

Go Between [26], *First Light* [28], *Drink Me* [29], *Bind* [30] and *Above Ground* [31] were, with *Stand Point,* all included in Denny's representation in the British Pavilion at the Venice Biennale of 1966. Venetian light, with that combination of clarity and filtered evenness it gets from continual reflection into the air from water, is famous for what it does for colour in painting, and Denny has seldom had conditions so favourable for bringing out the full subtlety and richness of his colour as on this occasion. It was particularly an occasion for showing a painting like *First Light* which actually evokes an effect of illumination. The term 'shadowed colour' is more than usually appropriate to the blending of dark green-blue, dark ochre and purple in the central panel, when this panel is framed in clear, cool blue which seems like dawn rising behind a monolith. Denny's colour harmonies had always been far from

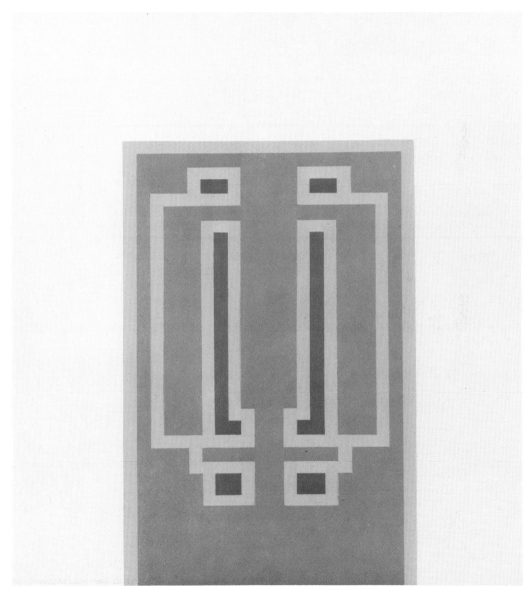

28. *First Light,* 1965–6

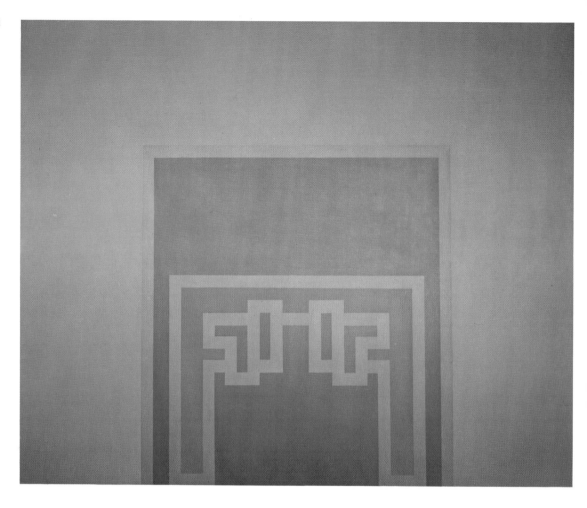

29. *Drink Me,* 1965

30 (opposite). *Bind,* 1965–6

obvious, and they achieve a new sophistication in the work of this year. But it is the nature of the images he now arrives at which changes most. In the first place they tend to be low-set, several of them broad and weighty and settled towards the bottom half of the painting. His images had always been inclined to be more active in the area from head-level downwards, but now the whole of them sometimes lay below the normal field of vision. *Above Ground,* apart from punning on the sense of a perceptual figure/ground relationship, is an image that takes ground to mean floor-level. This is even truer of *Drink Me,* which was in fact the most downwardly-compressed image he had devised so far, the reference being to the bottle in *Alice in Wonderland* whose contents made Alice shrink (*Garden* [33], a slightly later painting, is also an *Alice in Wonderland* title, referring to her subsequent quandary of

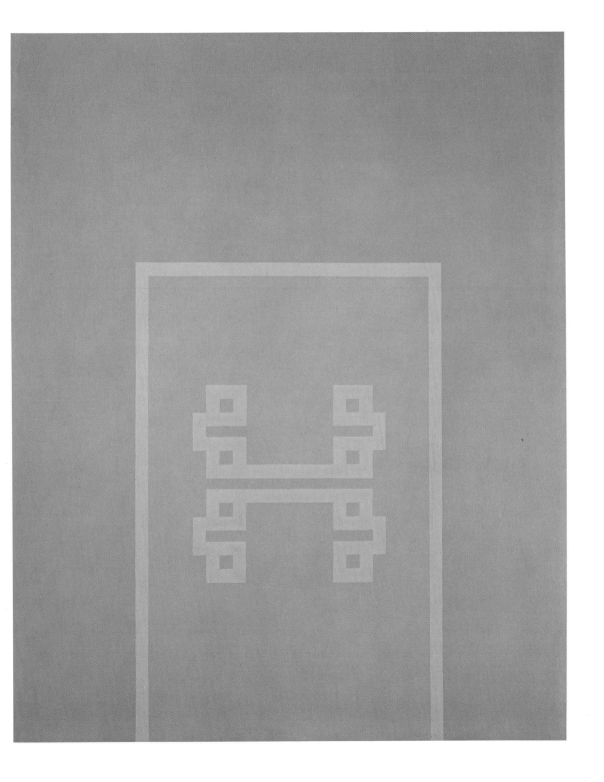

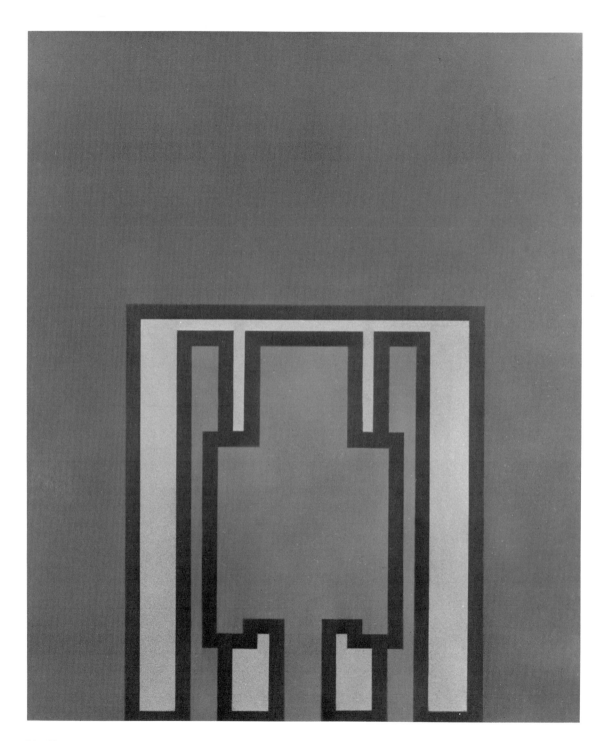

31. *Above Ground,* 1965–6

seeing a garden through the door she had by then grown too big to go through).

This inclination of the images to take up rather physically exceptional positions (there are others, such as *Over Reach,* which lift upwards as much as some press down) is one aspect of a general tendency for them to express a sort of action rather than express a state of being. Activity in earlier paintings had been of the perceptual kind that works through colour-reversal, spatial illusion or linear movement. Now there are individual knots of incident, usually linked by implied or actual continuity through the linear bands but sometimes separate and isolated in the central field (as they are in both *Bind* and *Go Between*). These knots of incident seem to work like parts of the body executing a gesture — in *Above Ground* a hunched but upright stance; in *First Light* a gesture clenched at top and bottom of a wide-circling vertical stretch; in *Go Between* a lateral stretch above and below an opened gap; in *Bind* a pulling apart of knots. To describe them in such terms is of course too literal: they are not themselves in any way descriptive images, and there are other ways of reading what they do. On the other hand, analogies between sign and gesture, shape and physical action, go back in Denny's awareness of abstract imagery to his earliest experiments with writing and alphabets and to the thesis he compiled at the Royal College. There are no jumps in his thinking or shooting off at a tangent in his practice. His work is at any one stage a complete synthesis of everything that has led him to that stage, and to a remarkable degree, considering the variety in his development, one can say that each Denny painting contains all that has gone into every other Denny painting.

The more simplified formal imagery continues through 1967, in paintings like *Remember* [32], *Garden* [33] and the *By Day* series [34, 35]. Even the knots of incident which in *Bind, Go Between* or *Drink Me* had suggested a touch of *chinoiserie* are ironed out in a return to shapes almost as severe as *Dumb* [27]. This repeated paring down of various elements in Denny's style hardly demands explanation in itself: most artists aim at refining and condensing their means of expression. But he was heading towards a major stylistic change in 1968 and 1969, and although this change was mainly to affect his colour, something of what it was to involve is possibly prefigured in these simplifications of the image. He was to find himself re-defining the illusionistic aspects of his art and challenging them, as it were, with new aspects of the real. This is what seems to be happening already in his images. They are more like *things* in the middle of the canvas, less like signs or gestures and even less like linear maze-situations,

46 even if all these functions are still present. One remembers Alloway's analogy of the control-board in the paintings of 1960, for there are now forms like interconnected boxes or like panels with gear handles and levers (particularly in the unusual *By Day 3* [35]). The *By Day* series, however, brought another consideration back into focus. It was painted during Denny's semester at Minneapolis, where the physical expanses of America's mid-west were bound to recall that link between the experience of a certain natural environment and the experience of a new pictorial space which had often been thought to operate in American painting's sheer sense of scale. But it happened also to be winter, and the effect of brilliant sun off blinding snow confirmed Denny's feelings about the role of natural light in painting. The variety and diversity-in-unity he had always required of a picture whatever its apparent simplicity,

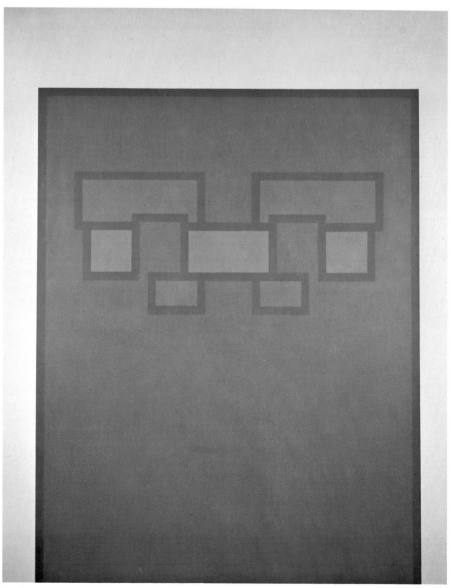

32. *Remember,* 1966–7

could be created by the performance of light alone on a surface. The *By Day* paintings, with their predominant wintry blues, are also predominantly light-paintings.

This in itself was enough to anticipate a reconsideration of colour, though two projects during 1968 which were not independent paintings also involved the related problem of scale. One was a further commission for a mural (his fourth), this time for the re-modelled Paramount Cinema in Lower Regent Street, London [38], the conversion of which into two cinemas in the one building was being designed by Denny's brother. It was technically a complicated commission because of the need to work in relief with acoustic panels, allowing gaps for air-conditioning vents, and starting from a dark background with the minimum concession to the effect of reflections from the screen. Denny's solution, in two subtly differentiated

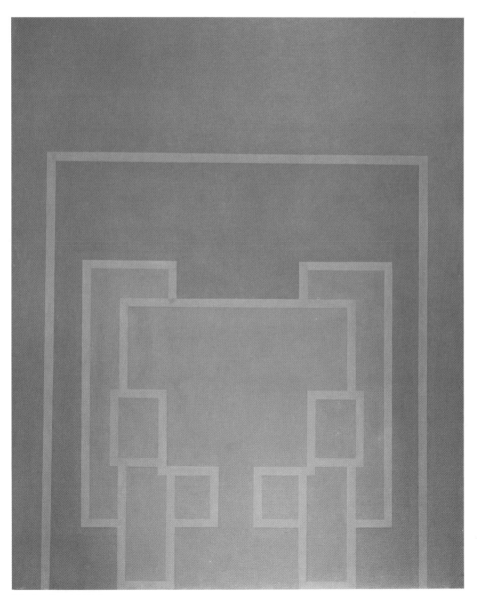

33. *Garden,* 1966–7

designs on opposite walls, involved panels of purple and green with white contours elaborately interwoven across the breaks and intervals between them. Colour-sketches in gouache and drawings on squared paper had contributed to its working out, and it is significant that even in his paintings his working methods were again changing. Experience by now enabled him to anticipate most of the effects he was aiming for, including changes of scale, and he began more and more to plan in advance, first using full-scale drawings for transferring to canvas, and ultimately small drawings for enlargement.

Denny's second project independent of his paintings during 1968 was a set of five multiple screenprints published by Editions Alecto and called the *Colour Box Series*. The first thing to strike one about them is that the colours themselves are more brilliant and solid than any in Denny's work since 1961: they are confined to five elements of a colour-circle — scarlet, light orange, lime green, turquoise

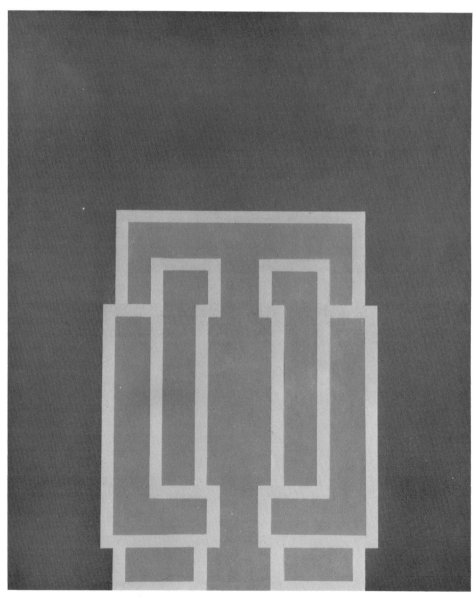

and violet. The second impression is that the compositions are of extreme formal simplicity, virtually resolved into squares and coming down to a small square flanked by near-square rectangles set in a horizontal slab very low and forward in the design: this structure remains constant throughout the series. The third impression is that there is no linear element as such: the image entirely depends on flat planes of colour superimposed on each other. But most important of all is that the superimposition is not illusionistic, but real. The colours are printed separately, at full strength and as uninterrupted planes, on clear acrylic sheets, and the final image only appears when the sheets are laid in order one on top of another.

The work is a highly analytic re-examination of Denny's basic concern with colour read as space. The layers stepping back through the composition are now no illusion. On the other hand, the series is a five-part transformable picture, with each component of the colour-circle coming to the front in turn, and this means that illusion, or at least an apparent denial of the reality, creeps in again by the back door. For while a certain tonal recession is achieved merely by the depth of the plastic at various levels, a strong *colour* further back will still press optically in front of a lighter *tone* at the surface. The interchange between illusion and reality becomes cyclic, particularly as the fifth colour variation in the circle leads inevitably back into the first. Considered as a totality, the series even suggests a different *occupation* of space by colour: a cyclic sequence should ideally be seen ranged round in a circle.

The complex rationale of the *Colour Box Series* makes it very evident how closely the conceptual and the perceptual are allied in Denny's art. In the paintings first shown in 1969, like *A Time* [1], *Time of Day 1* [36] and *When* [37], which continue the new brilliance of hue and absence of linear imagery, the ruling idea is more than ever that of a structure, a concept. Yet it is a structure perceptually modified. Colour will be modified by drawing, the drawing continually modified by the colour until each confirms and depends on the other, while the entire structure is further affected by light. Idea and realization lock together by mutual refining, which is not in the nature of things a rapid process. One of the reasons for 'time' titles for these paintings is that they demand continuous and concentrated attention in the painting, and demand hardly less in the viewing. They *take* time. But one needs, without playing too much with words, to note that that does not mean they are timeless. Denny, who is so often called a classical painter more or less automatically, in this respect at least shows himself to be at a significant remove from the generally accepted classical position. In the role

34 (opposite). *By Day 2,* 1967

35. *By Day 3,* 1967

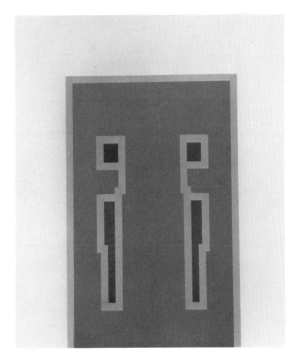

he assigns to colour above all, he is attempting almost the opposite of a timeless or a changeless art. He invokes the passage of time precisely in order to allow change to operate. He insists that the act of seeing is relative, conditional, non-conceptual. It is not frozen in the eternalized moment of classicism.

Denny's art has a characteristic but unusual quality of manifesting the values for which it stands. You do not necessarily get very far by describing a painting as (say) calm, self-contained and classically ordered: it could still be

a work of banal insipidity. Such qualities only carry weight within a fully understood and precisely declared hierarchy of values, and a Denny painting seems by its very nature to set the standard of values it is to be judged by. It is not a manifesto, and it is not didactic, but everything which is planned and perfectionist about it leaves no room for equivocation that its aims are of a high seriousness within a high order of art.

It stands in particular for two values one might risk calling 'absolute'. The first is simply the value of abstraction. Not because abstraction is something universally valid: it isn't. Nor because mainstream art in our mid-century has put an almost obligatory premium on it: that is not an argument for its virtue and is a questionable assumption anyhow. But because abstraction can represent the imagination's finest instrument for expressing distilled

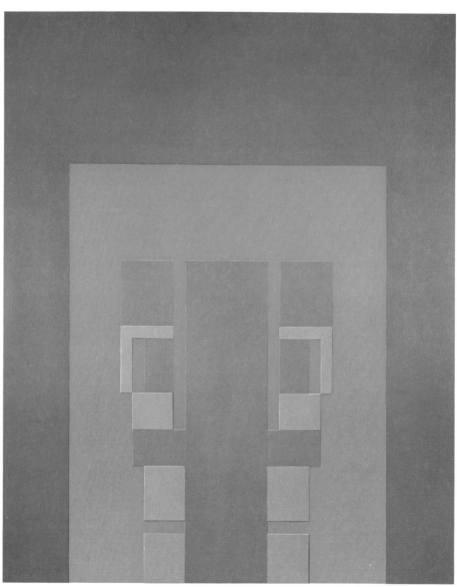

36. *Time of Day 1,* 1969

experience. Of course not all artists by any means are persuaded that 'distilling' their experience is the most interesting way of dealing with it. But for those who are, man's instinct to order and continually to re-define what he knows imposes certain obligations to stretch his imagination to the limits of its reach. Because Denny is an 'abstract' artist, he does not therefore rule out the implications and associations that cling round certain types of imagery. The recurring upright, central form in many of his paintings, for example, is in a sense the standing human figure, confronting the spectator as an objective and physical presence. The main theme of Giacometti's art is the same thing, and the stance of a Giacometti figure is conditioned by some of the same assumptions that govern Denny's rectangular, flat panel — namely, that anything which detracts from or fusses around with the two dis-

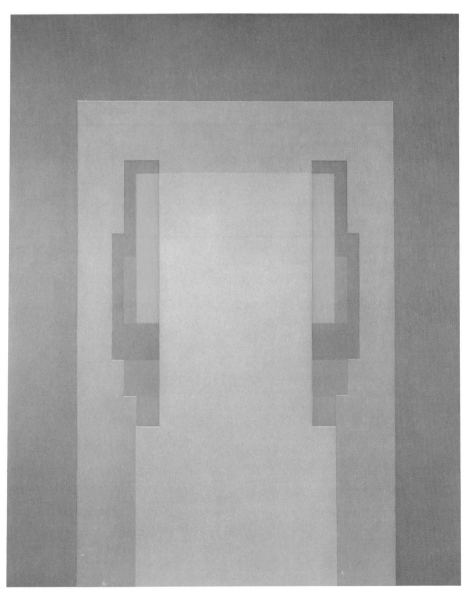

37. *When,* 1967

tinguishing qualities of centrality and uprightness will somehow compromise what a figure essentially *is*. Only a bolt upright and frontal stance, with hands to the side and feet together, *can* really encompass the idea of 'standing human figure'; any deviation from that pose would mean 'standing human figure doing something', which immediately involves an incident or an anecdote of some kind. Where Denny differs from an artist like Giacometti is in believing that such an image is not ultimately made less real or less objective as a human presence by pushing the abstraction to its logical conclusion. But it can gain in symbolic significance, and it is in this sense that his painting commits itself to the 'absolute' value of abstraction as an imaginative necessity.

The other value that it commits itself to is inherent in the whole complex of characteristics which are being referred to when he is called a classical artist. 'Classical' is an abused and shop-soiled word, but in its broadest sense it carries the implication of certain intrinsically superior values — inasmuch as order is superior to disorder, clarity to obscurity, the essential to the inessential, and so on. And in this broad sense, Denny's painting clearly exemplifies classical qualities and subscribes to classical virtues. The most characteristic manifestation of them, perhaps, is the perfected style: the most idiosyncratic, his use of symmetry.

Whatever goes on in the picture in the way of ambiguity or optical change, one's confidence in it is rooted in the knowledge that everything arbitrary has been removed from it. It is self-evidently the particular product of a particular deliberation, the success of which is to be judged by the immaculately finished state to which it has been possible to bring the result. 'Perfected', though, must be distinguished from 'perfect'. Denny's painting is not, strictly speaking, a quest for the ideal. This is where 'classical' as a blanket-term of description or value has to be guarded against. As early as 'Situation' Alloway was combating its use in connection with painting like Denny's, by trying to insist that resorting to 'economical but ambiguous colour/form' was not the same thing as being interested in pure or ideal elements for their own sake.[8] And it is worth recalling what Denny and Richard Smith had said in 1961 in their 'project for a film', *Ev'ry Which Way:* 'Intermittent stimuli make a montage in the variety of which it is fruitless to search for universals. This film would not be a one and only attempt to find a true reading, but as in a painting it is relevant to the preceding and succeeding work, but not a step towards some final solution valid for all time.' It is not, in other words, the perfection of some ideal state which is classical in a Denny painting, but the

ordering, perfecting habit of mind which brings it to its own relevant state of completeness.

Denny's use of symmetry is of course part of the effect of completeness. It gives the image a closed and balanced look, emphasizes its centrality and frontal aspect. But it is so nearly the one obsessional habit of a painter one doesn't think of in any other way as obsessional, that one has to regard it as something rather more than a practical format. It is Denny's sign-manual, informing every development of style and every variety of image. It can be rationalized in terms of its frontality as a mirror-image given back to the spectator who confronts in it the analogy of symmetry in his own body. It can be rationalized as the only way of implying a centralized spatial perspective which allows infinite extension in depth without compromising the flatness or direction of a two-dimensional surface. These are perfectly relevant considerations, but they evade the basic issue which is that symmetry is what gives a Denny image its characteristic solemnity − its iconic, ritual, hieratic presence. Of the forty or so recognized types of symmetry, Denny's simple bi-lateral type is not conceptually the most mysterious. Even so, it assumes something of the symbolic function of all symmetry to connote the unnameable and the unimaginable: something, that is to say, of the spiritual content of both the idol and the mandala. One could call this the mystical side or the mystical implication in Denny's work (most critics at some time or other recognize that it has such a quality, though they usually acknowledge it with the less specific word 'mysterious'). But again there would seem to be some contradiction of the classical idea in so describing it. The classical idea tends to be humanist and to avoid suggestions of the numinous, and perhaps the subtlest emotional judgement in a Denny painting lies precisely in its balance of feeling between these positions. The 'mystery', as was suggested in the first part of this essay, is contained within a human sense of scale and the classical-humanist context of an architectonic structure.

Denny's classical bias, and particularly his symmetry, in one way sets his work apart in the English tradition as a whole, and certainly marks it off from the work of both his older and his nearer contemporaries of a comparable formal persuasion. Classicism is only to a limited degree an 'English' preoccupation, and in this century has tended to be a neo-cubist one. Both a painter like Ben Nicholson and a movement like British constructivism are too cubist-orientated to relate at all to what Denny is doing. Yet at the same time, a conspicuous 'Englishness' in, as it were, the tone of voice, is precisely what distinguishes Denny from

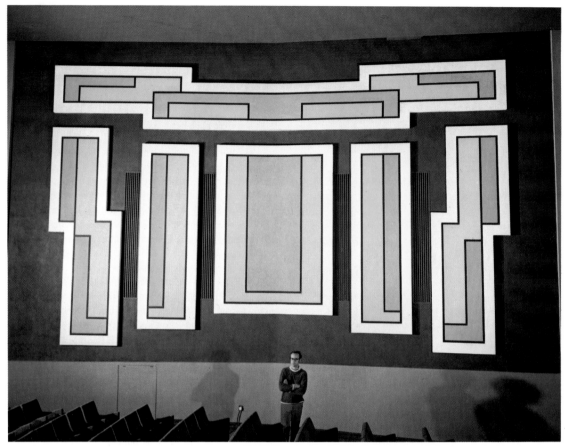

38. *Acoustic mural,* 1968

those of his immediate contemporaries who might be supposed to be nearest to his own concerns. To the outside observer, from New York for instance, it is one of his essential characteristics. Whenever his art is described as 'muted', 'hushed', 'bland', 'reticent', the choice of adjectives conjures up an archetypal conception of English 'reserve'.

Denny has himself always been conscious that special responsibilities and problems of identity attach to the fact of being a British painter in a cultural climate affected by America. The basic issues in modern painting are not, strictly speaking, resolvable in terms of national character, and Denny would not see himself in any relevant sense as particularly either a British-type painter or an American-type painter. On the other hand, it *is* meaningful to be aware of oneself as a painter in a certain place at a certain

time. Some aspects of the observable Englishness in Denny's painting can fairly be called aspects of an English inheritance. There is in the first place its linear quality, however modified or transformed that may be by non-linear concerns. Linearism has always been regarded as a traditionally English bias, but in Denny's work one is reminded of two specific precedents. It is not irrelevant that he is of Irish descent, and it has been remarked that the interlacing character of his line has something of the 'sober Irish interlace' of illuminated manuscripts.[9] It has also been likened to the patterning of eighteenth-century formal gardens, and the imagery it defines called 'Neo-Palladian'[10]: the comparison is shrewd, for the English classical strain has mainly been channelled, as one could feel it has in a Denny painting, through the language of architectural

style. A further English inheritance would appear to be the strong emphasis on a tonal reading of colour. Again this is obviously in part a by-product of particular pictorial and perceptual concerns, but it is equally clearly a temperamental bias. The quality of light seen as space seen as tonality has always been of much greater importance in the English tradition than any preoccupation with form: it could be called that tradition's distinguishing characteristic.

But as important as any inherited or traditional English qualities that can be inferred from Denny's style, are those aspects of his work which mark it as post-war British as distinct from anything American. In London, in the later fifties, the climate of interest in communication-theory, mass-media, games-situations and urbanism had no counterpart in New York and never affected the thinking of painters as it did in this country. It resulted, on the one hand, in a concern with the role of perceptual ambiguity and, on the other, in an independent interpretation of American-inspired scale which between them made a new kind of British painting possible. The idea of spectator-involvement in particular was a response to the 'big picture' which was without American precedent. American painting could, as Alloway pointed out, 'immerse you in the picture', but its scale was a 'side-effect of painting the things'[11]: it was conditioned by thinking of the picture as an arena large enough to contain an event. But in London, scale was immediately interpreted as lateral space, and space as an aspect of environment, of the organization of urban living, and of communication-control. Whereas New York aesthetics were basically centred on personal self-expression, London aesthetics had a strain of social consciousness. Denny's own attitude has already been discussed in connection with his 'Togetherness?' article and his contribution to 'Place'. It involved a concept of public art, the desire for which is a desire for intelligibility — the creation of a context in which aesthetic experience can be made communal. Denny's art is still profoundly rooted in these ideas. His approach to scale, to illusionism, to imagery is, as it always has been, conditioned by his conception of spectator-involvement.

The other distinguishing mark of recent British painting as exemplified in Denny's own practice can be summed up in the word 'ambiguity'. The kind of American painting which affected Denny's generation most has at its best been an art of almost overwhelming risk. Its greatest triumphs have been achieved by daring to push to extremes: it is 'the art of extreme situations'. At its less than best, it has been very largely an art of reductive aesthetics (which crudely means an art based on extreme situations that don't work). In neither case is there much room left

for development nor a compulsive inducement to follow where the original purpose had been to reach the end of the line. Even apart from that, neither could appeal indefinitely to the European mentality. The mere existence of a meaningful past conditions the European to a different complexity of response: impact is not all. The long-term reaction of many British painters to the American experience has been to absorb a much-needed lesson, but finally to become persuaded that, for them at least, the reductive aesthetic of 'less is more' can very easily degenerate into a reductive aesthetic of 'less is less'. Ruthless simplification has its virtues, but there comes a time when more is to be gained from putting things back than from continuing to take them out. Complexity, without sacrificing the lessons learnt, has again become for the British painter a necessary condition of the art. He has recaptured the semantics of painting and found in the ambiguous reading, the ambiguous situation, a truer and more subtle reflection of what experience means to him.

Denny is still only in mid-career. But whatever the particular directions his future development may take, it is safe to assume that the general commitment of his work will remain much the same as it has been from the beginning. It will deepen rather than change. What has been remarkable in his development so far has been the total consistency, not of his style, but of his basic convictions about what a painting is supposed to mean and to do. These seem to have crystallized for him very early, largely perhaps because intellectual analysis and detached critical thinking come naturally to him (he is one of those rare artists able to write as intelligently as he paints), and also because the climate of discussion in London at the time he was a student provided exceptional opportunities to argue out his premises and have their validity tested there and then. His most mature painting, as a result, can be foreseen to some degree in his earliest work, just as the earlier is still contained in, and relevant to, the later. He has never had to abandon a basic position because it became untenable, with the single exception of the free, gestural manner of his first. But even then there were implications behind his use of gesture which remained valid even when the method of expressing them had to be changed. It is because all his basic premises are at work simultaneously in all his paintings, whatever internal shifts of emphasis there may be from time to time, that his art achieves a consistent richness, subtlety and complexity even when he is being at his most stringently economical in his means of expression. He has been one of the most unfaltering British painters of his time, as well as, quite simply, one of the most important.

1   Interview in *Isis* ' "Situation"; The British Abstract scene
    in 1960', 6 June 1964, pp. 6–9
2   Lawrence Alloway, catalogue introduction to 'Dimensions',
    O'Hana Gallery, 1957
3   Lawrence Alloway, 'English and International Art',
    *European Art this Month,* vol. 1, nos. 9/10, 1957, pp. 25–6
4   Lawrence Alloway, 'Size Wise', *Art News and Review,*
    vol. XII, no. 17, September 1961, p. 2
5   Interview in *Isis*
6   Lawrence Alloway, 'Size Wise'
7   Lawrence Alloway, catalogue introduction to Denny's
    one-man show at the Molton Gallery, November/Decem-
    ber 1961
8   Lawrence Alloway, 'Situation in Retrospect', *Architectural
    Design,* vol. XXXI, No 2, February 1961, pp. 82–3
9   David Bourdon, 'The Mod Artists', *Village Voice,* (New
    York), 16 December 1965
10  Martin Friedman, catalogue introduction to 'London: The
    New Scene', Walker Art Center, Minneapolis, 1965
11  Lawrence Alloway, 'Making a Scene', *Art News and
    Review,* vol. XI, no. 18, September 1959, p. 2

'Language, Symbol, Image' (thesis, Royal College of Art), 1957.

'Ev'ry Which Way', a project for a film (with Richard Smith), *Ark,* 24 (4-page pull-out), 1959.

'Togetherness?', *Gazette,* (edited by Lawrence Alloway, Gordon House, William Turnbull) No. 1, 1961.

'London Report', *Das Kunstwerk,* XVI:4, October 1962, pp. 46–7.

'London Report', *Das Kunstwerk,* XVI:5/6, November/ December 1962, pp. 79–80.

'London Report', *Das Kunstwerk,* XVI:7, January 1963, pp. 41–2.

'London Letter', *Art International,* VII:4, April 1963, pp. 68–9.

'London Letter', *Art International,* VII:5, May 1963, pp. 64–5.

'A Note on Francis Bacon and Henry Moore', *Art International,* VII:7, September 1963, pp. 49–52.

'Creative Process', *Conference on Design Methods* (edited by Christopher Jones and D. G. Thornley), Pergamon Press, 1963, pp. 185–93.

'London Letter', *Art International,* VIII:4, May 1964, pp. 51–4.

' "Situation"; the British Abstract Scene in 1960' (Robyn Denny interviewed), *Isis,* no. 1468, 6 June 1964, pp. 6–9.

'Robyn Denny Answers Questions about his Work', *Monad,* I:1, (Chelsea School of Art), Summer 1964, p. 29.

'Interview with Robyn Denny' (Anthony Carter), *London Magazine,* June 1966.

'Ad Reinhardt: an appreciation', *Studio International,* 174:895, December 1967, pp. 264–5.

'Charles Biederman', catalogue introduction to exhibition at the Hayward Gallery, Arts Council, September 1969.

'Charles Biederman: from the actual to the sublime', *Studio International,* 178:914, September 1969, pp. 65–7.

Other articles    Lawrence Alloway, 'English and International Art', *European Art This Month,* vol. 1, nos. 9/10, 1957, pp. 25–6.

Roger Coleman, 'Two Painters', *Ark,* 20, 1957, pp. 23–6.

Lawrence Alloway, 'Grande-Bretagne: le geste et la sémantique', *XX Siècle,* no. 10, March 1958, pp. 65–7.

Roger Coleman, 'Figure/Field Work', *Art News and Review,* vol. XI, no. 16, August 1959, p. 2.

Lawrence Alloway, 'Making a Scene', *Art News and Review,* vol. XI, no. 18, September 1959, pp. 2–3.

Alan Bowness, 'Smith, Denny and Rumney in "Place"', *Arts,* vol. XXXIV, no. 20, September 1959.

Roger Coleman, catalogue for 'Place' exhibition, Institute of Contemporary Arts, London, September 1959.

Roger Coleman, 'The Content of Environment', *Architectural Design,* vol. XXIX, no. 12, December 1959, pp. 517–18.

Lawrence Alloway, 'Situation in Retrospect', *Architectural Design,* vol. XXXI, no. 2, February 1961, pp. 82–3.

Jane Harrison, 'Robyn Denny', *Arts Review,* vol. XIII, no. 22, November 1961, p. 18.

Lawrence Alloway, catalogue introduction to one-man exhibition, Molton Gallery, London, November/December 1961.

Michael Fried, 'The Winter's Tale', *Arts,* vol. XXXVI, no. 5, February 1962, p. 65.

Norbert Lynton, 'Natural Art', *New Statesman,* 20 March 1964.

John Russell, *Private View* (Robertson, Russell, Snowdon), Thomas Nelson & Sons, 1965, pp. 240–41.

Martin Friedman, catalogue introduction for 'London: The New Scene' exhibition, Walker Art Center, Minneapolis, 1965.

David Bourdon, 'The Mod Artists', *Village Voice* (New York), 16 December 1965.

Edwin Mullins, 'Robyn Denny', *Art and Artists,* vol. I, no. 3, June 1966, p. 32.

David Thompson, catalogue introduction, 'Five Young British Artists', XXXIII Venice Biennale (British Council), 1966.

Norbert Lynton, 'Robyn Denny', *Guardian,* 16 June 1967.

Richard Morphet, catalogue introduction, 'Jeunes Peintres Anglais', Palais des Beaux-Arts, Brussels, (British Council), October 1967.

Kermit Champa, 'Recent British Painting at the Tate', *Artforum,* vol. VI, no. 7, March 1968, pp. 33–7.

Sydney Simon, 'Robyn Denny', *Art International,* vol. XII, no. 4, April 1968.

Robert Kudielka, 'Robyn Denny's "Colour Box"' (London Commentary), *Studio International,* vol. 177, no. 907, January 1969, pp. 42–3.

1   *A Time,* 1969. Oil on canvas, 96 x 78 ins. Collection: Kasmin Ltd, London (photo: Jasper Jewett).

2   *Painting 17,* 1956. Oil on board, 30 x 25 ins. Collection: Kissner, U.S.A. (photo: Robyn Denny).

3   *Maquette for Austin Reed mural,* 1959. Collage and mixed media on board, 14 x 24 ins. Collection: the artist (photo: Kim Lim).

4   *Mosaic mural,* 1959. Mosaic, 120 x 120 ins. Collection: Abbey Wood Primary School, London (photo: Greater London Council).

5   *Transformable 1,* 1959. Composition board, laminated. Nine interchangeable sections, each 15 x 15 ins. Collection: the artist (photo: Kim Lim).

6   *Living In,* 1958–9. Oil on canvas, 78 x 96 ins. Collection: the artist (photo: Robyn Denny).

7   *Home from Home,* 1959. Oil on canvas, 78 x 96 ins. Collection: the artist (photo: Robyn Denny).

8   *Place 3,* 1959. Oil on canvas, 84 x 72 ins. Collection: the artist (photo: Robyn Denny).

9   'Place' — installation shot of the exhibition at the Institute of Contemporary Arts, Dover Street, London, September 1959. The paintings in the centre (see 8) and to far right, left and far left of the photograph are by Robyn Denny. The two others, seen more frontally, are by Ralph Rumney (photo: Roger Coleman).

10   *Baby is Three* (triptych), 1960. Emulsion on canvas, 84 x 144 ins. (each panel 84 x 48 ins.). Collection: the artist (photo: Jasper Jewett).

11   *7/1960,* 1960. Oil on canvas, 90 x 54 ins. Collection: the artist (photo: Jasper Jewett).

12   *Frontman,* 1961. Oil on canvas, 96 x 78 ins. Collection: Michael Michaeledes (photo: Jasper Jewett).

13   *Wardrop 1,* 1961. Oil on canvas, 96 x 78 ins. Collection: Liverpool University (photo: Brompton Studio).

14   *Track 4,* 1961. Oil on canvas, 72 x 69 ins. Collection: the artist (photo: Jasper Jewett).

15   *Gully Foyle,* 1961. Oil on canvas, 84 x 72 ins. Collection: The Peter Stuyvesant Foundation, London (photo: Jasper Jewett).

16   *Out-Line 5,* 1962. Oil on canvas, 60 x 48 ins. Private collection (photo: Brompton Studio).

17   *Out-Line 3,* 1962. Oil on canvas, 60 x 48 ins. Collection: Doberman, Munster (photo: Jasper Jewett).

18   *Life Line 1,* 1963. Oil on canvas, 84 x 72 ins. Collection: The Tate Gallery, London (photo: Brompton Studio).

19   *Jones's Law,* 1964. Oil on canvas, 84 x 72 ins. Collection: The British Council (photo: Jasper Jewett).

20   *Connections,* 1964–5. Oil on canvas, 84 x 72 ins. Collection: the artist (photo: Brompton Studio).

21 *Secrets,* 1964–5. Oil on canvas, 84 x 72 ins. Collection: John Kasmin (photo: Brompton Studio).

22 *For Ever,* 1965. Oil on canvas, 84 x 72 ins. Collection: The Peter Stuyvesant Foundation, London (photo: Jasper Jewett).

23 *Shade 2,* 1964–5. Oil on canvas, 84 x 72 ins. Collection: the artist (photo: Jasper Jewett).

24 *Into Colour,* 1964–5. Oil on canvas, 84 x 72 ins. Collection: Formerly Robert Elkon, New York (photo: Jasper Jewett).

25 *Stand Point,* 1965–6. Oil on canvas, 96 x 78 ins. Collection: the artist (photo: Jasper Jewett).

26 *Go Between,* 1964–5. Oil on canvas, 96 x 78 ins. Collection: the artist (photo: Jasper Jewett).

27 *Dumb,* 1964–5. Oil on canvas, 94 x 72 ins. Collection: Robert Elkon Gallery, New York (photo: Jasper Jewett).

28 *First Light,* 1965–6. Oil on canvas, 96 x 78 ins. Collection: The Tate Gallery, London (photo: Jasper Jewett).

29 *Drink Me,* 1965. Oil on canvas, 96 x 78 ins. Collection: Lord Hartington (photo: Jasper Jewett).

30 *Bind,* 1965–6. Oil on canvas, 96 x 78 ins. Collection: the artist (photo: Jasper Jewett).

31 *Above Ground,* 1965–6. Oil on canvas, 96 x 78 ins. Collection: Galerie Müller, Stuttgart (photo: British Council).

32 *Remember,* 1966–7. Oil on canvas, 96 x 78 ins. Collection: Ulster Museum, Belfast (photo: Jasper Jewett).

33 *Garden,* 1966–7. Oil on canvas, 96 x 78 ins. Collection: The Tate Gallery, London (photo: Jasper Jewett).

34 *By Day 2,* 1967. Acrylic on canvas, 96 x 78 ins. Collection: the artist (photo: Hartwell, Minneapolis).

35 *By Day 3,* 1967. Acrylic on canvas, 96 x 78 ins. Collection: the artist (photo: Hartwell, Minneapolis).

36 *Time of Day 1,* 1969. Oil on canvas, 96 x 78 ins. Collection: Kasmin Ltd, London (photo: Jasper Jewett).

37 *When,* 1967. Oil on canvas, 96 x 78 ins. Collection: Kasmin Ltd, London (photo: Jasper Jewett).

38 *Acoustic mural,* 1968. Oil on fibrous plaster panels, 20 x 38 ft. Paramount Cinema, Lower Regent Street, London (photo: Jasper Jewett).